Appaloosa Spirit

SPIRIT OF THE HORSE SERIES

Words By Audrey Pavia

BOWTIE
P R E S S

Images By Bob Langrish

For Rosie
—A.P.

Ruth Berman, editor-in-chief
Nick Clemente, special consultant
Doug Kraus, designer

Library of Congress Cataloging-in-Publication Data

Pavia, Audrey.
 Appaloosa spirit / words by Audrey Pavia ; images by Bob Langrish.
 p. cm. -- (Spirit of the horse series)
 ISBN 1-889540-15-3
 1. Appaloosa horse. I. Title. II. Series.
SF293.A7P386 1998
636.1'3--dc21 97-32192
 CIP

The horses in this book are referred to as *he* or *she* in alternating chapters,
unless their gender is apparent from the activity discussed.

Additional photographs courtesy of: pp. 12, 13 © Dusty L. Perin; p. 30 © Kim
and Kari Baker; p. 57, The Appaloosa Horse Club.

BowTie™ Press
3 Burroughs
Irvine, California 92618

Manufactured in the United States of America

First Printing May 1998

10 9 8 7 6 5 4 3 2 1

Table of Contents

C H A P T E R 1

Horse of the Nez Percé ...5

C H A P T E R 2

Uniqueness and Beauty..17

C H A P T E R 3

Working Heritage..29

C H A P T E R 4

Spotted Babies...39

C H A P T E R 5

The World Show...51

C H A P T E R 6

Conclusion ..59

Glossary...64

Horse of the Nez Percé

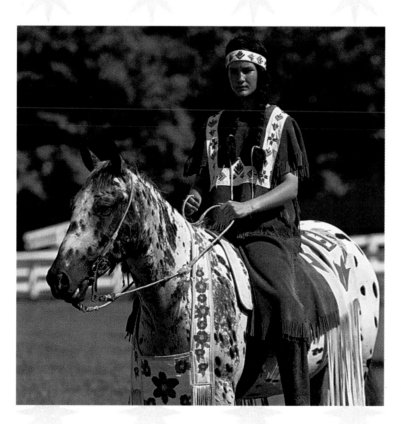

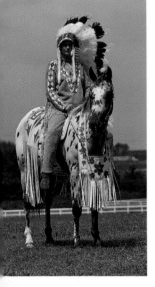

Their forms moved among the trees, silent and noble. They were women, children, the sick, and the elderly carrying the few possessions they had. They trudged over the leaf-strewn ground, up the steep trail, one after another by the hundreds. Above them, tall pines grew, rising gradually to the sky. Below them, a downhill drop into another sea of green-blue forest. The path was narrow—only two people at a time could walk it abreast.

There were warriors too on the trail, and they were tired and angry—angry they were being driven from their homeland, angry the U.S. Government had lied to them yet again, angry they, their people, and their treasured horses were forced to struggle simply to exist.

It was hard for them to travel at a good speed. The cavalry, but two days behind them, was unencumbered by little children and old women. Despite their desperation, there was one thing these brave warriors would not sacrifice: their vast herd—horses whom they drove over the narrow trail by the hundreds. On that harsh, rugged path high in the Bitterroot Mountains, these troubled people fought not only to save themselves, but also to save their cherished animals, bred carefully for so many suns. To the warriors, these horses were not just livestock; each was a soul mate, a creature who would give his life for his human. They were Appaloosas, a kind of horse that the Nez Percé knew to be exceptional.

Chapter One

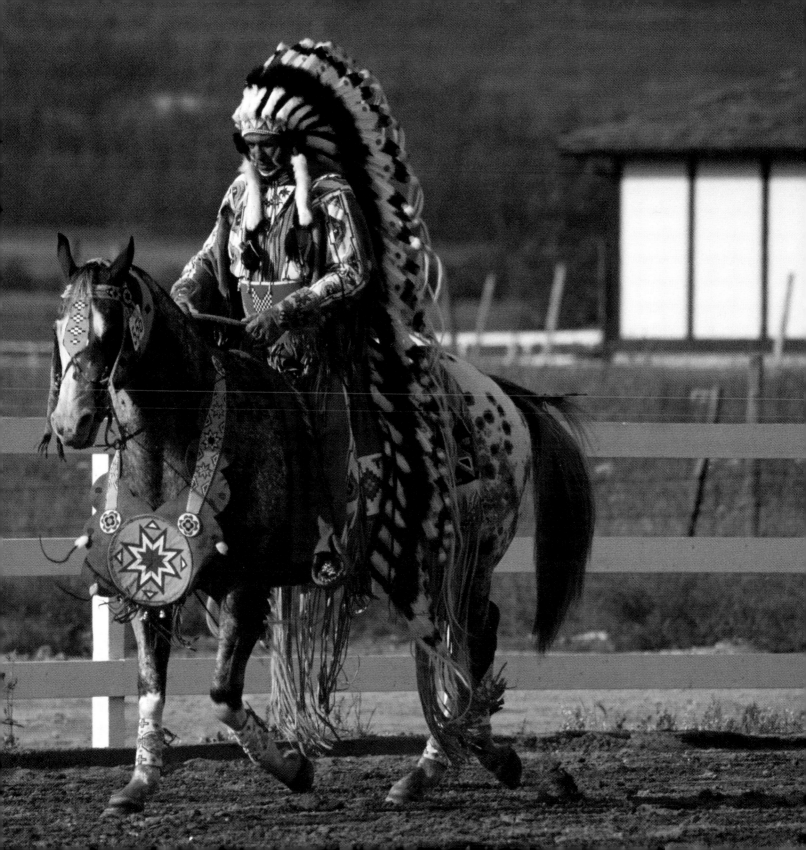

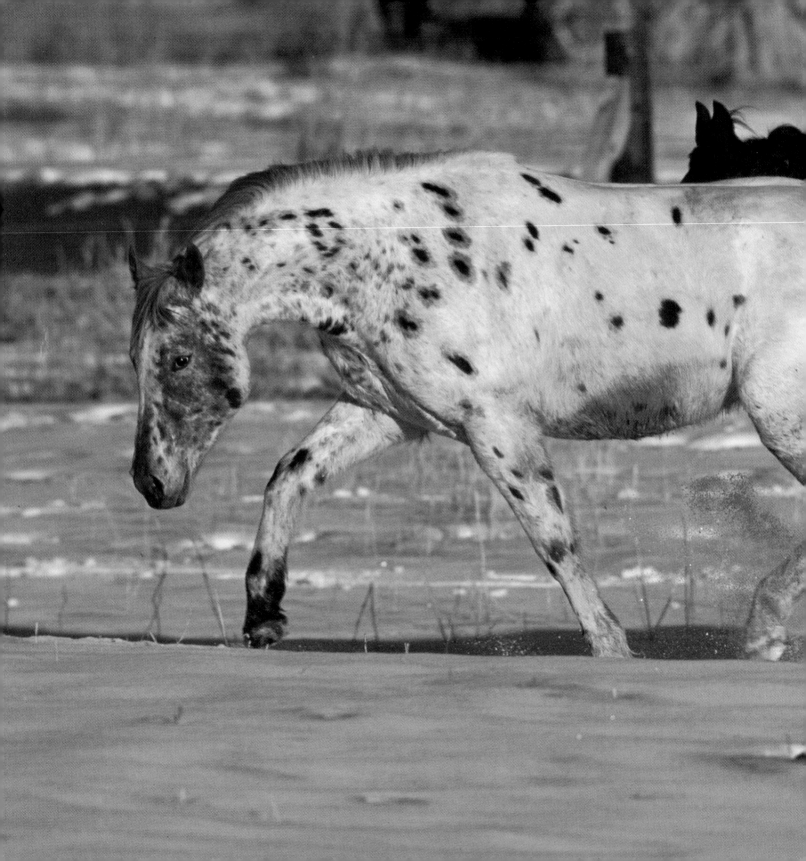

The story of the Nez Percé's flight from the U.S. cavalry has been told many times in history books. The tribe had lived for centuries in the Palouse Region of the Pacific Northwest, among its valleys and surrounding mountains, in harmony with the land. Traveling to hunt buffalo on the prairies of what is now Montana, harvesting camas roots from the valleys below the Bitterroot Mountains, and perfecting the skills of horsemanship were an integral part of the Nez Percé people's existence. They wanted nothing more than to go about their lives. But it was not to be.

In 1877, the Nez Percé entered a war with the U.S. government, and the entire tribe with all of its horses embarked on a journey that would take them 1,300 miles in three months

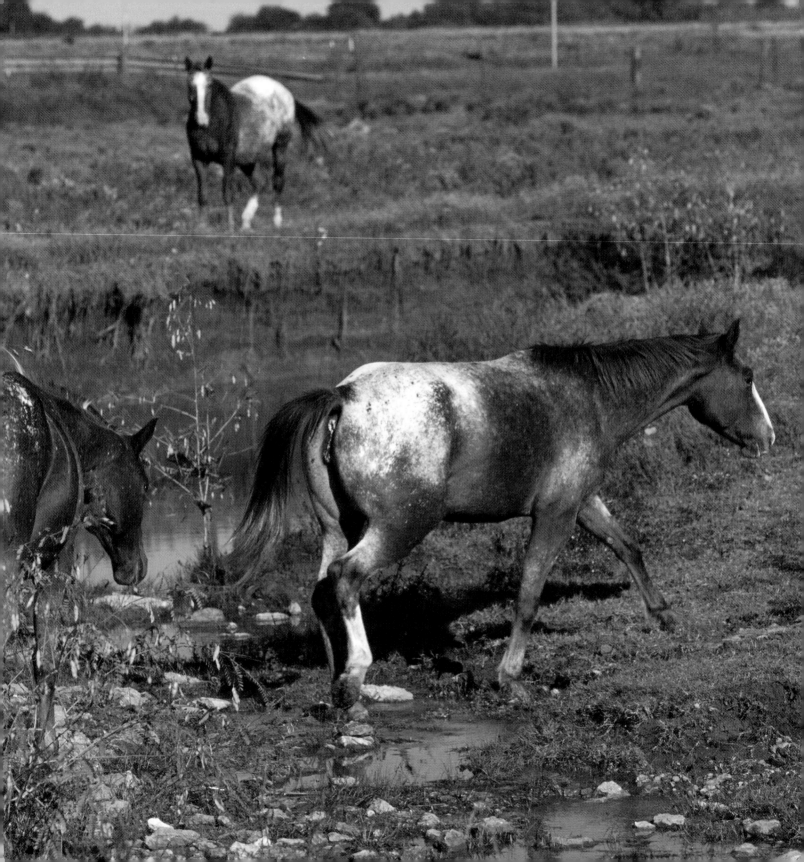

toward the country of Canada, where they hoped to find refuge. Along the way, many people and horses were lost to the harshness of the terrain and the bullets of encroaching soldiers. But the tribe pressed on, fleeing for its very life, trying desperately to hold on to all that it knew.

Only a few miles before they reached the border of Canada, the Nez Percé were besieged and outnumbered by the U.S. cavalry. Chief Joseph, their great leader, surrendered. There was sadness in his heart: sadness for the many people lost, sadness for the land he would never see again, sadness for the horses, whom his people had treasured above all else. Chief Joseph and his captured people were taken far away from their homeland, and the horses, those who had not escaped into the hills, were deliberately destroyed by army gunfire.

Why did the Nez Percé people love their horses so dearly? The answer is simple. They knew they had something remarkable. They knew the Appaloosa was no ordinary horse.

There are two stories about how the Appaloosa first came to live with the Nez Percé. One tells of horses, descendants of the mustangs brought to the New World by the Spaniards, who arrived from the south. Among the horses traded to them by other tribes, these spotted creatures caught the eye of the Nez Percé people and soon became the tribe's horse of choice. While this theory is the one most often cited by historians, there is another account, one handed down through the oral tradition of the Nez Percé.

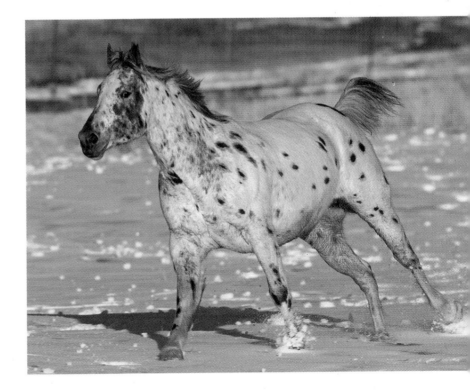

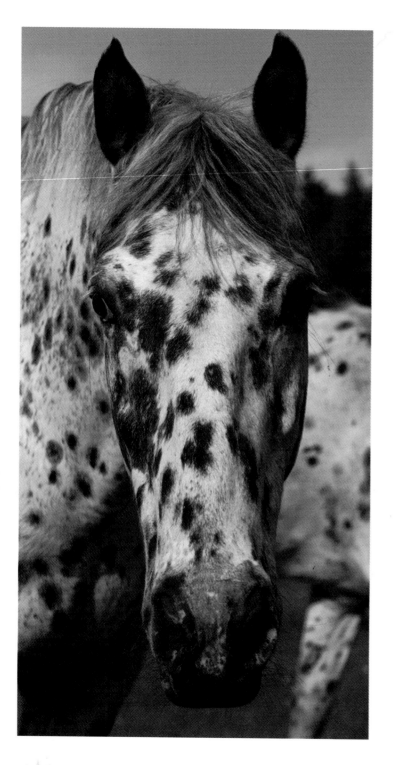

It is a story of three stallions who came from the sea to the land of the Nez Percé. It happened hundreds of years ago, before our country was born. A ship from a faraway land we now know as Russia came to the shores of the Pacific Northwest. The stallions were sent from the ship to swim to Nez Percé traders, who received these amazing creatures with awe. Tradition tells of their silvery white bodies, of black marks on their faces and legs, and speckles on their muzzles.

These stallions had powerful medicine. When they were bred to the tribe's mares, this medicine was passed down to their young. Known as the Ghost Wind Stallions, these three horses are believed by some to be ancestors of the Appaloosas, whose history mingles so closely with that of the Nez Percé.

But despite these varied theories, one fact remains undisputed: Wherever the Nez Percé's Appaloosas came from, they had a speed, an endurance, a disposition, and a coloration that set them apart from all other horses.

As much as the Nez Percé loved their spotted companions, the tribe's enemies feared them more. Wild and ferocious in battle, it was said the Nez Percé horse was trained to charge an enemy and knock him from his mount. The horse would then attack the man, striking him with its hooves and tearing at him with its teeth. But this same animal, said to be vicious on the battlefield, would be cared for later that night by a young child whose job it was to tend to the

warriors' horses who had fought well in battle.

The Nez Percé horse was also famous for its speed—its ability to outrun a buffalo and to beat other tribes' horses in short, fast races as well as in long, grueling rides. The endurance of this colorful creature became legendary beyond the boundaries of the Nez Percé region when, generations later, the U.S. cavalry pursued the tribe and found it could not keep up. The horse soldiers soon learned that they could only beat the Nez Percé by outnumbering them, and that they did.

Although the Nez Percé were captured and taken to a reservation, their horses lost in the mountains or killed by soldiers, a few Appaloosas remained. Scattered around the

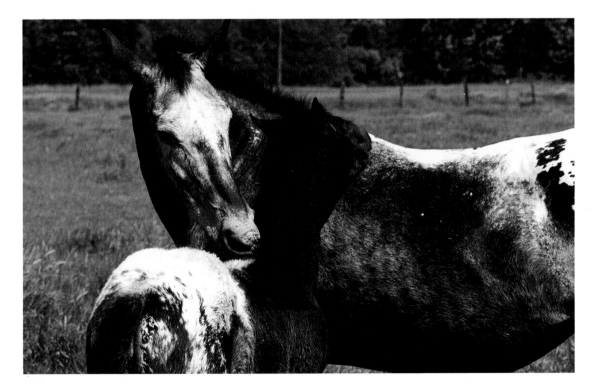

West and recognizable by their unmistakable color and conformation, these horses still had advocates. Some whites continued to breed them quietly, seeking to preserve the same traits the Nez Percé had so painstakingly developed. Just before the second World War began, a small group of these people came together to form the Appaloosa Horse Club, and they became the official caretakers of the breed.

These new guardians of the breed began a search to find horses whose closest ancestors had survived the decimation of the Nez Percé tribe. They found one stallion with a Nez Percé Indian man, a rancher who had been breeding horses for decades. The ancestors of his animals had come from Chief Joseph's herd. Another horse was discovered in the mountains of northern Colorado, the product of a mustang mare and a leopard-spotted stallion. And these were just two. Over the next few years, nearly 5,000 horses were sought out and designated as the foundation for the "new" Appaloosa breed.

Lovers of this horse recognized their awesome responsibility to Chief Joseph to safeguard the Appaloosa—to preserve the traits of the horses the great chief called *my children*. Since these dedicated horsemen came together in 1938, more than 580,000 Appaloosas have been registered with the Appaloosa Horse Club.

Chapter One

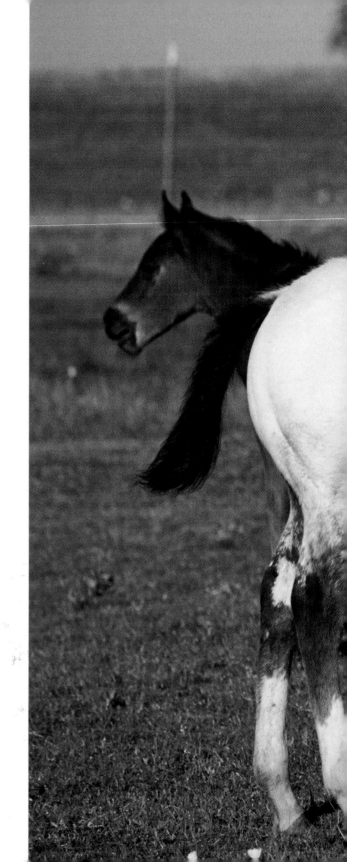

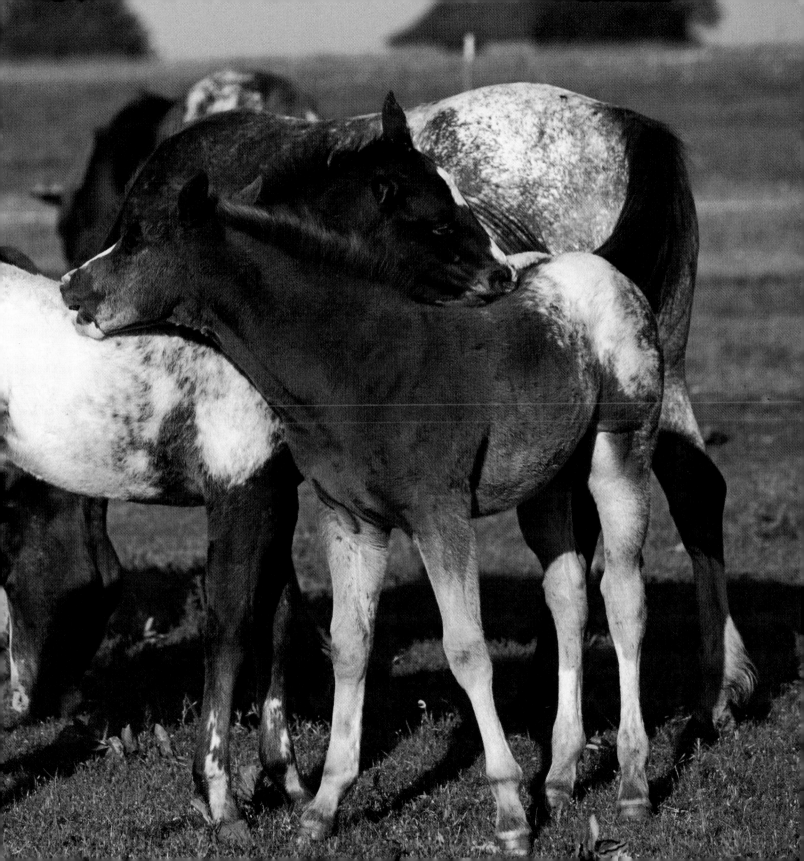

Uniqueness and Beauty

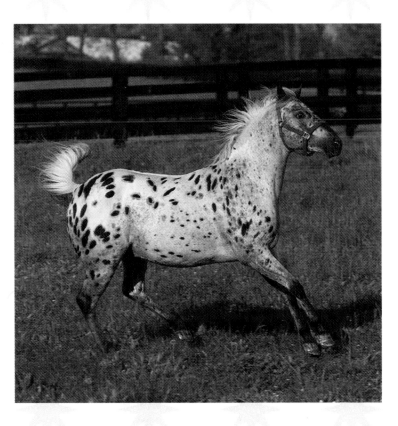

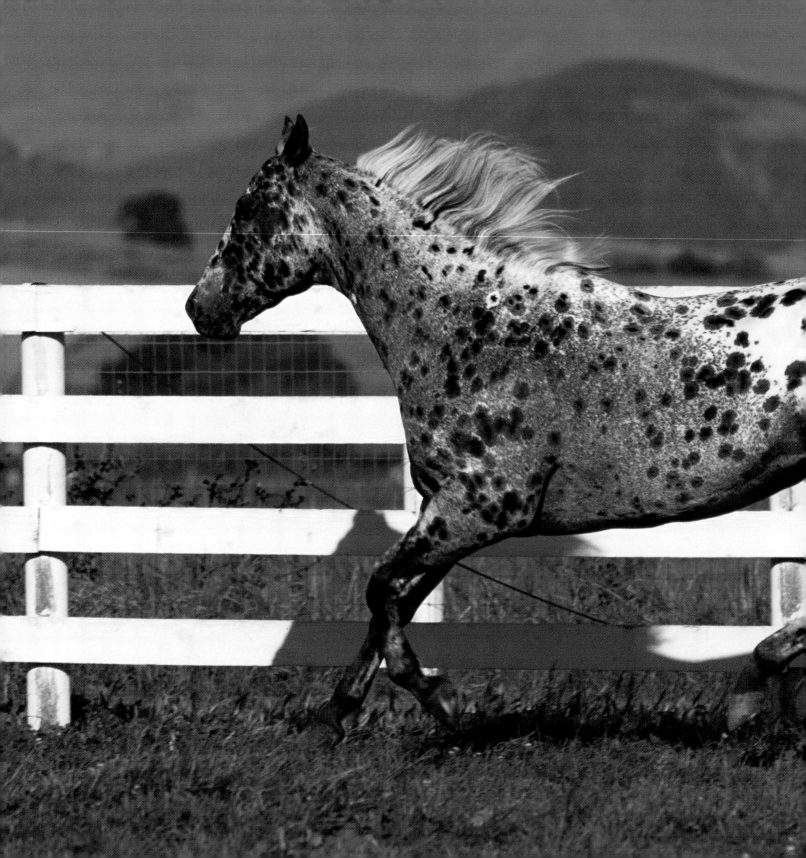

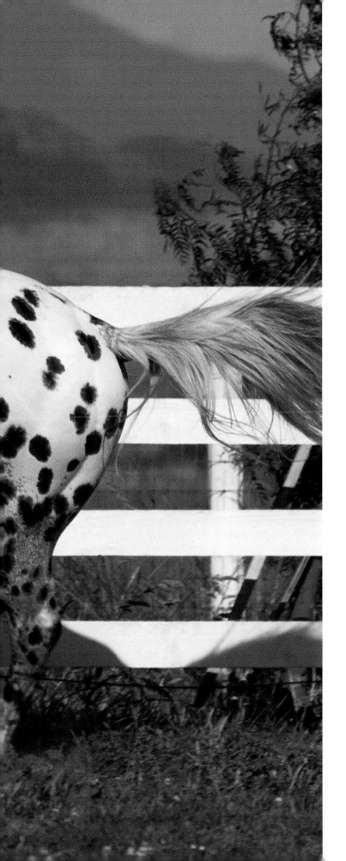

A light goes on in her eyes as she discovers her freedom. Head up, tail waving in the air, she bolts from a standstill and begins to run. As she picks up speed, her neck stretches out and her muscles ripple. She becomes a tornado of spots as she sails madly into the wind.

It is easy to imagine her as she gallops along, with a Nez Percé warrior astride her, his bow drawn and pointed at a buffalo he has chosen from the herd. The buffalo knows he has been marked and runs for his life. He is fast—very fast. Most horses would be easily outrun by this massive yet nimble creature. But not this horse. She has been running for miles, but when her rider asks her for more speed she responds with a burst of power. She closes in on the buffalo,

Uniqueness and Beauty 19

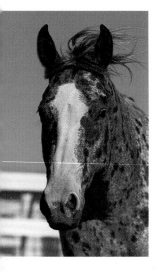

her ears back, her nostrils wide with excitement. Alongside him now, she feels her partner shift his weight ever so slightly as he releases the bow. It's a perfect shot. The bull careens to the side and crashes to the ground. The warrior lets out a cry of victory. The mare surges forward, her heart pounding.

And then there's the Appaloosa color. Imagine a herd of Appaloosas grazing on the lush grasses of a Pacific Northwestern valley: mares with tiny foals at their sides, and geldings who had once been foals. While there are solid, spotless horses among them, the eye is drawn to the horses of color. They stand knee-deep in the grass, grinding the vegetation down with their powerful jaws and swishing deer flies with their gossamer

Chapter Two

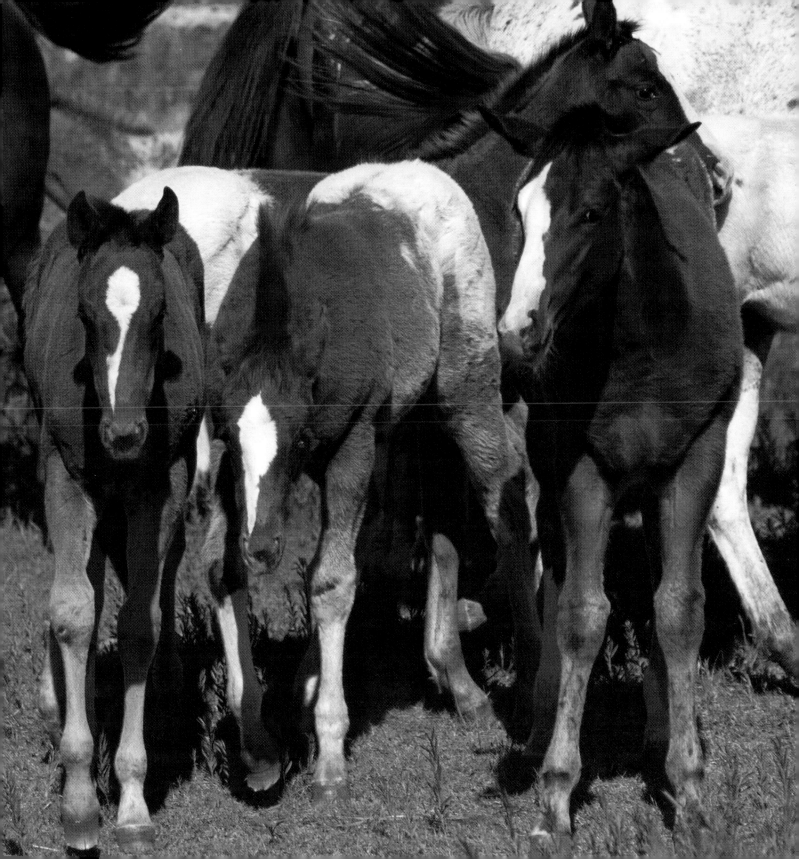

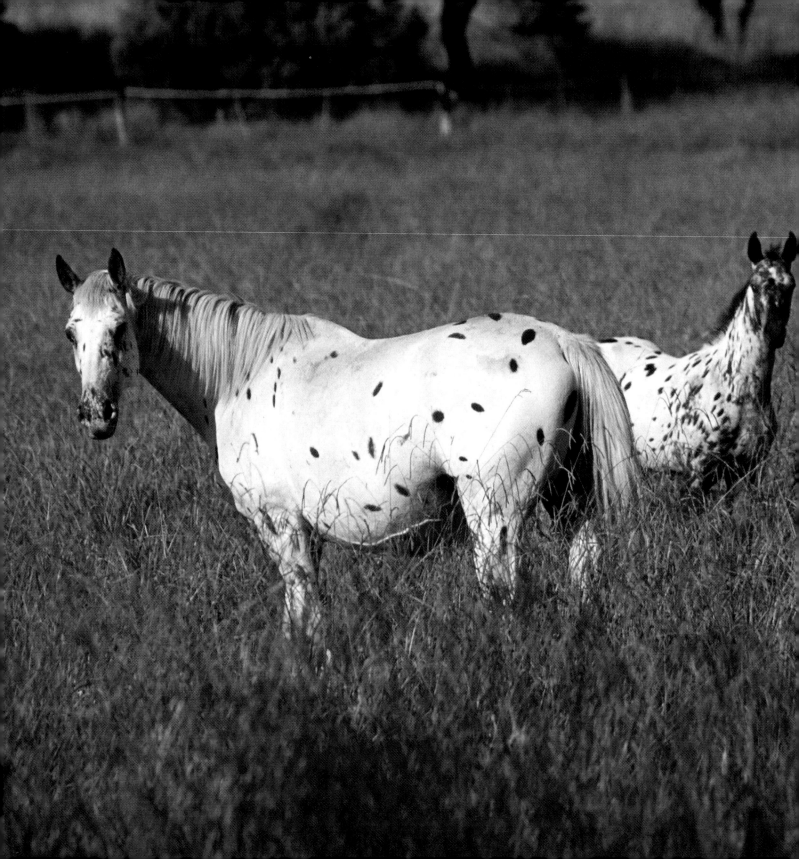

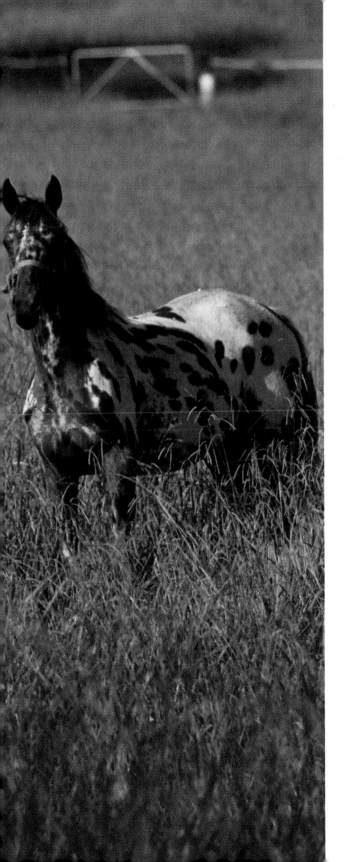

tails. As individuals, they are striking; as a group, they are extraordinary, bombarding our vision with a spectacular array of patterns.

We see bays with large white blankets, stretching from their tails to their shoulders, covered with big black spots; and chestnuts with stark, spotless white rumps. There are dark horses with snowflake patterns and light horses with marble patterns. But that's not all. There are leopards among these horses, their bodies white in the sunshine, their dark, egg-sized spots leaping off their coats. Each spot is black or brown, with a hazy shadow encircling it—like a sunspot.

In the herd, there are the more subtle patterns: blue roans with frosted hips; few-

Uniqueness and Beauty

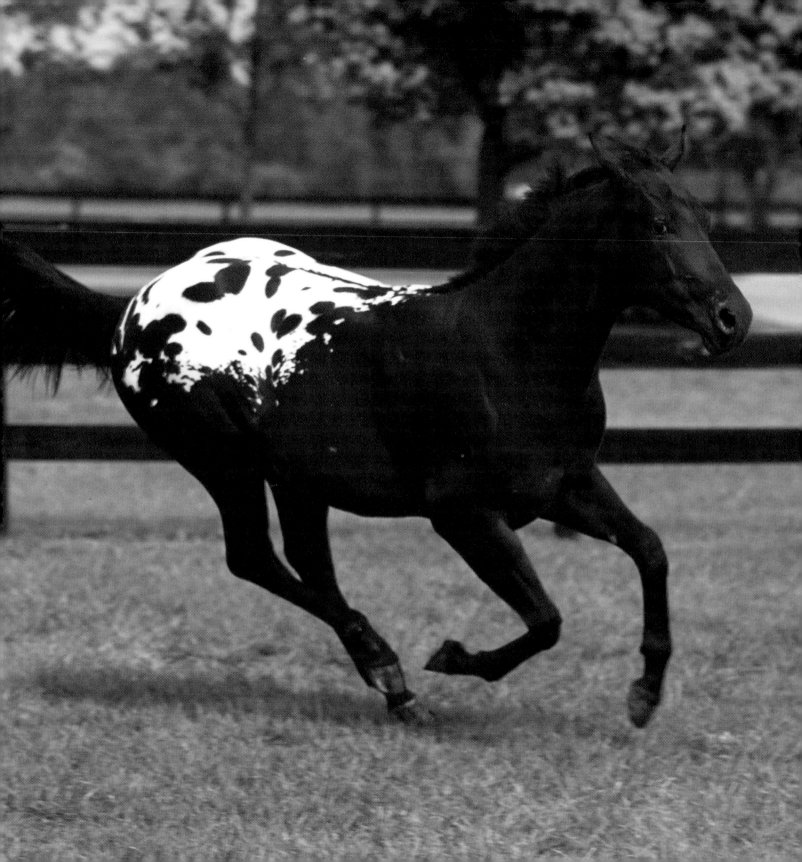

spot leopards, white with black varnish on their legs and faces; red roans with bloodlike droplets covering their bodies.

If you watched them for many months, you would see that some of their coats are ever changing: some of the solid foals of loudly colored mares will grow up to roan and blanket; a few of the roan foals who started out dark will mature to be white with black markings. One mare's mottled coat will change with the seasons. Summer finds her a shiny copper, her hair glowing brightly in the blazing sun. In winter, she turns to a soft rose color that blends gently with the powdery snow.

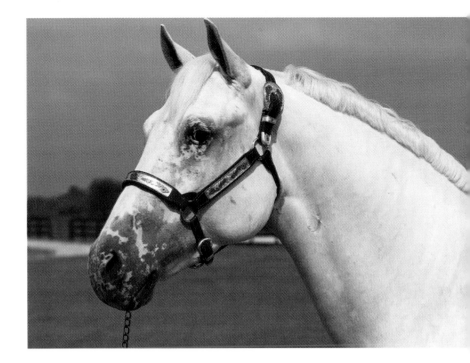

But coats are only part of the story. Characteristics found only in this breed and present in all true Appaloosas cannot be missed. The irises within their eyes are circled in light, resembling a human's: dark in the center with white sclera all around. The skin of their muzzles and genitalia is mottled. Their manes and tails are short and wispy. And their rock-hard hooves are striped with lines that reach from the ground toward the sky.

All of this has a purpose. With the eyes come great expression to match the human-like personality. The spotted skin shows strong Appaloosa genes that will be passed on to future generations. The faint mane and tail are elusive and will not catch in the dense forest of the breed's native terrain. And the striped hooves are strong and durable, enabling the Appaloosa to carry her rider for days on end.

The Appaloosa's body itself is built for sturdiness and speed. Her deep chest, muscular thighs, and sloping pasterns provide her with endurance and agility. Her head is straight and lean, with a profile signifying intelligence and dignity. She is a picture of overall balance and refinement, and when combined with all that color, she is a sight to behold.

The Appaloosa's strength and power might lead one to believe that she is a giant horse, one of great size and stature. While the breed can vary in size, the majority of Appaloosas stand an average of 15 hands—large enough to hold the weight of a rider comfortably, yet moderate enough to be mounted from the ground and move easily through forests. All these traits cultivated by

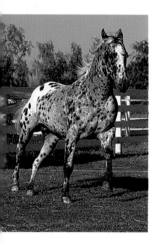

the Nez Percé—traits that were brought to the modern Appaloosa by the great foundation horses of the breed—are traits that Appaloosa breeders strive for today.

Who were these horses responsible for passing on the genes of the Nez Percé warhorse; horses with lineage so strong that they have carried the traits of Chief Joseph's horses into the twenty-first century? Their monikers are simple: Toby, Absarokee Sunset, Apache, Bright Eyes Brother, Joker B, Mansfield Comanche, Wapiti, Quanah, Red Eagle, Sundance—to name a few. And they were unassuming horses, most of them working animals used on western ranches. They were not the fancy show horses we see today, although they did excel at showing once the breed officially joined the established horse world. Their main purpose was to work and to sire foals who could work. When they were asked to demonstrate their skills in the show ring, they obliged. But first and foremost, they were rugged creatures who grazed the western grasses and weathered the cold western winters.

Chapter Two

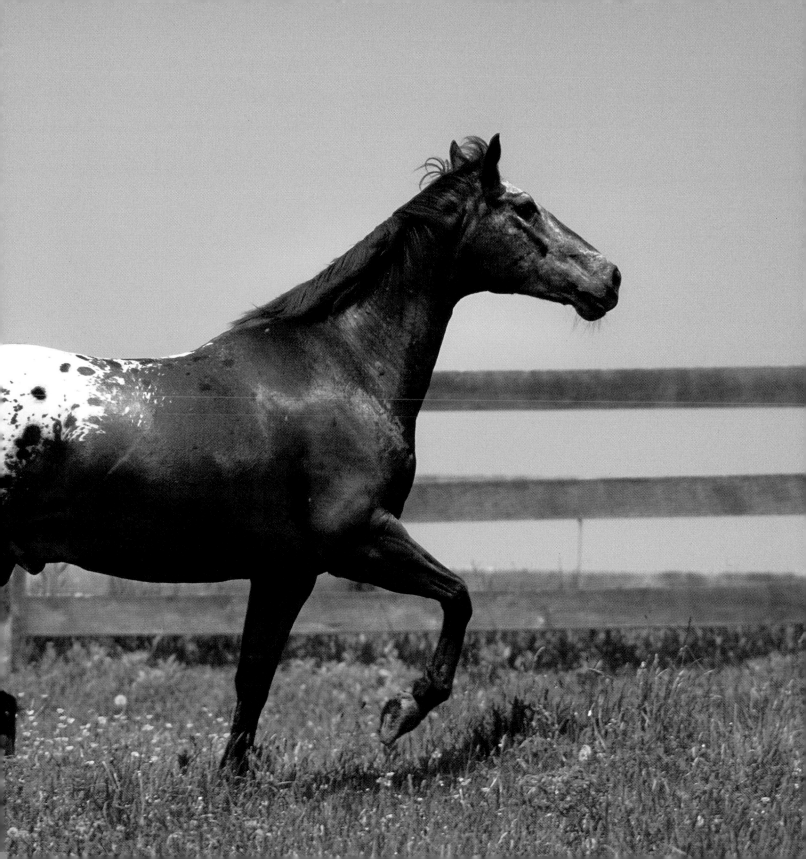

Working Heritage

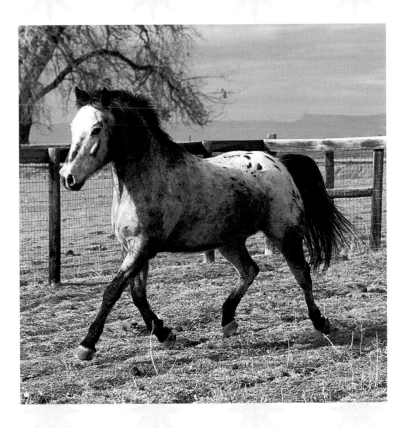

Chapter Three

Given the Appaloosa's history with the Nez Percé people, it is only natural that much of this breed's later work would entail taming the rugged landscapes of the West. Slowly, as the breed began to grow in numbers after its official recognition, its presence began to be felt more and more on ranches throughout the land.

Now, as then, the Appaloosa is a common sight on the range. Ridden by experienced cow hands who live hard yet romantic lives, Appaloosas work side by side with their human companions, spending long days bearing the saddle, taking their riders from one end of a spread to the other. They cut cattle, rope steers, and walk endless fence lines that stretch as far as the eye can see. In the spring, they are the ones who push the cattle from their winter grazing lands to the higher ranges, and in the fall, they bring them back down again.

Today, much of our country's land has been paved over. Where pristine forests once stood there are buildings that reach to the sky. But while this has taken away some of the earth, it has succeeded in providing a new job for the Appaloosa. City dwellers, hungry for nature, come to the West by the thousands to taste the dust of working cattle ranches and smell the sweet air of the alpine forests. The Appaloosa, with his surefootedness and gentle temperament is there, waiting to carry these unfamiliar riders to new experiences they will never forget.

And there is no better horse to do the job than the Appaloosa. Walking up steep slopes,

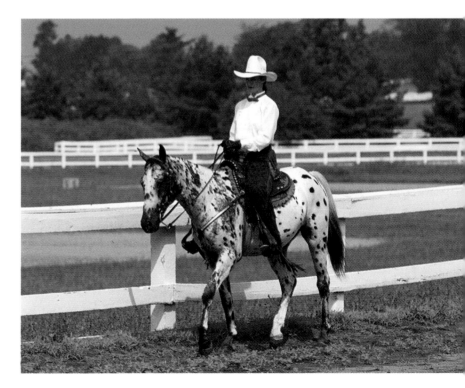

 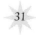

stepping through rocky crevices—this kind of traveling is old news for the spotted horse. Whether surrounded by towering pine trees or fields of waving grass, the Appaloosa carefully takes his rider over miles of natural terrain. Here is the ultimate trail horse—a bridge between humanity and all that is wild. It is easy to feel a part of this creature, whose spirit is so closely connected to the earth, and be at one with the land.

Although it may seem like a dichotomy, these traits of the ultimate trail horse are what make the Appaloosa a candidate for yet another job—dressage. This ancient discipline, developed during classical times, is often described as equine ballet, and the Appaloosa has what it takes to do it. Thinking about the horse's past, it all makes sense. The Nez Percé horse was easily trained, completely focused on his rider. Athletic and highly disciplined, this horse used his body in ways never known by cavalry mounts and feral mustangs. Agility and precise movements were needed to dodge attackers and outmaneuver buffalo. It is little wonder that more and more riders who cherish the tradition of dressage have chosen to request this skill of the Appaloosa.

The Appaloosa was seemingly born to jump, especially in the open. Those who seek the thrill of coursing through the countryside, negotiating water, trenches, and hedges, often call upon the inborn skills of the Appaloosa. Appaloosas leaping over obstacles at full gallop on the open land seem to feel the spirits of their ancestors urging

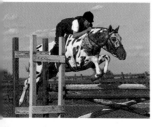

Chapter Three

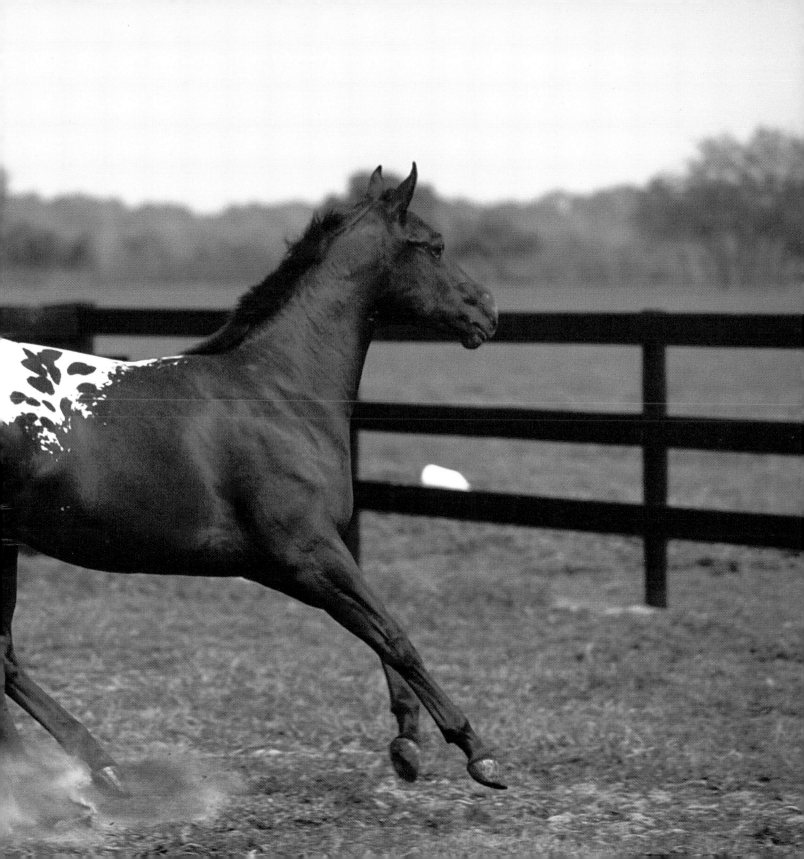

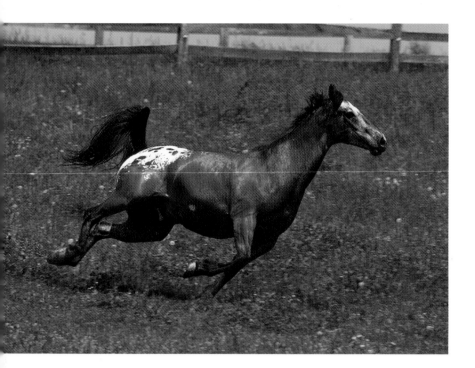

them on: time blurs by them, and suddenly, each one is running toward an enemy, hurtling over fallen trees and rocky ravines, taking his rider into battle. Long cross-country gallops with hurdles to overcome—what other breed could be better suited to this than one bred to carry warriors to battle, over rugged country filled with obstacles, and then back home again?

But open country is not the only place where the Appaloosa can jump. From show stadiums to lesson rings, Appaloosas carry riders over tiny cavalettis and towering walls. This breed thrives on excitement and jumps for the sheer joy of it.

And then there is their speed.

The Nez Percé had a love of racing, and this is deeply etched into the Appaloosa's

Chapter Three

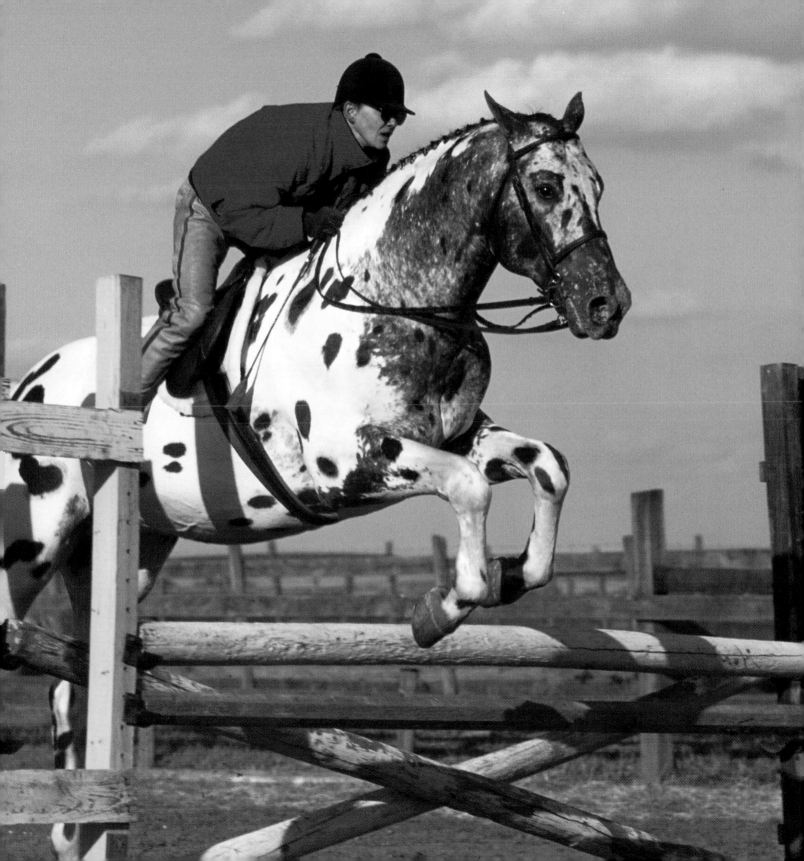

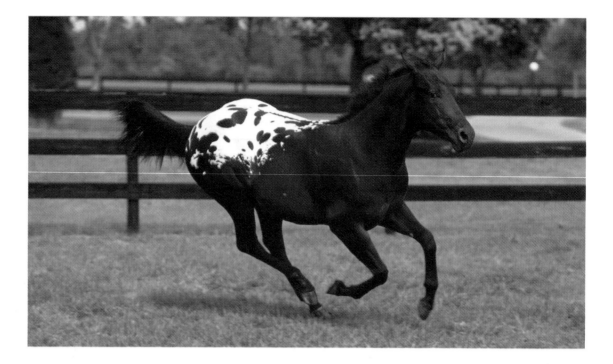

soul. Spotted horses were often pitted against one another, asked to challenge each other's swiftness over vast areas by the people who first bred them. The faster the horse, the more prized he was and the more he was bred, until the Appaloosa became a "ground-borne" Pegasus. Now, in our time, the Appaloosa continues to race against his brethren. On tracks around the country, spotted horses with winged feet strive to repeat the glory of their ancestors.

But the greatest job of all for the Appaloosa horse is that of companion. Here is a breed that the Nez Percé fought for, a breed that lived so closely with these people that the two were often viewed as one. During the time of the Nez Percé War, cavalry soldiers wrote in their journals of the obvious intimacy between the warriors and their steeds, describing braves who hung from their horses' sides like moss to vines. Nez Percé men grieved over their lost warhorses, while warhorses with fallen warriors went on to fight without them. Not mere mounts to be bought and traded, these horses were as dear to these men as their families. Each horse shared his warrior's triumphs and defeats, in life and in war.

The descendants of the Nez Percé Appaloosas share this ability to bond with the people who love them most. In a calm, gentle way, these Appaloosas give their souls, quietly, subtly. And once the bond is forged, there is nothing that can destroy it—not even death.

Chapter Three

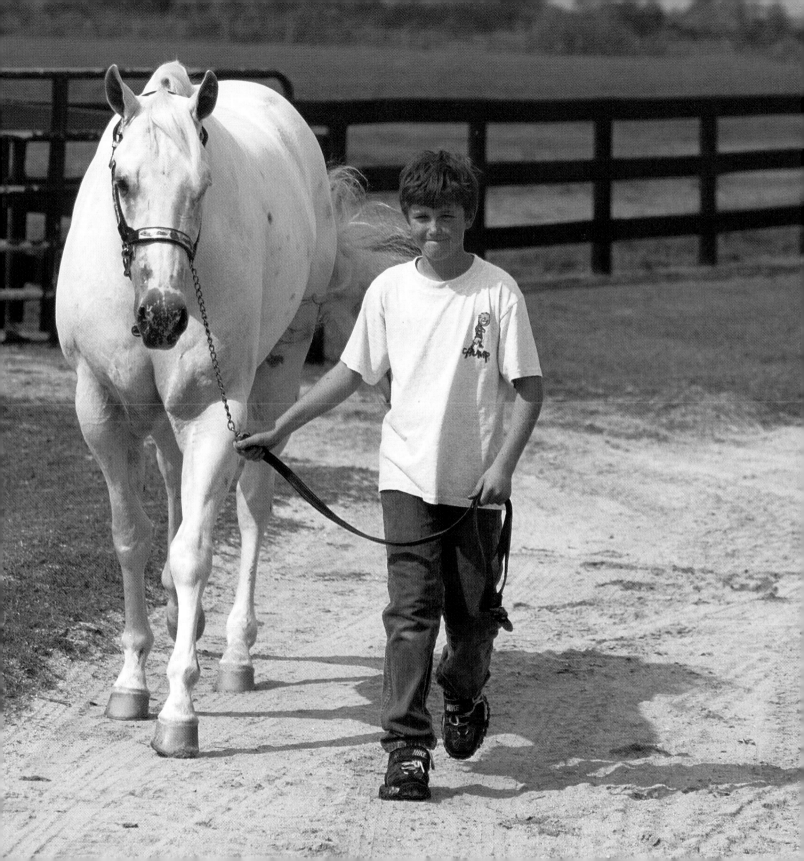

Spotted Babies

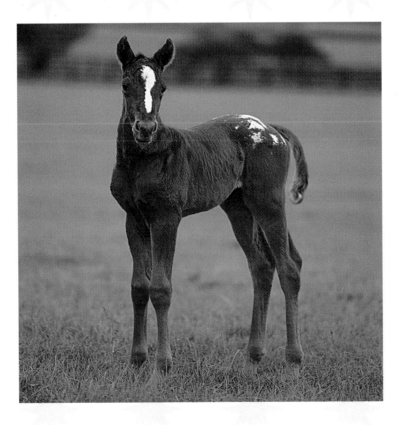

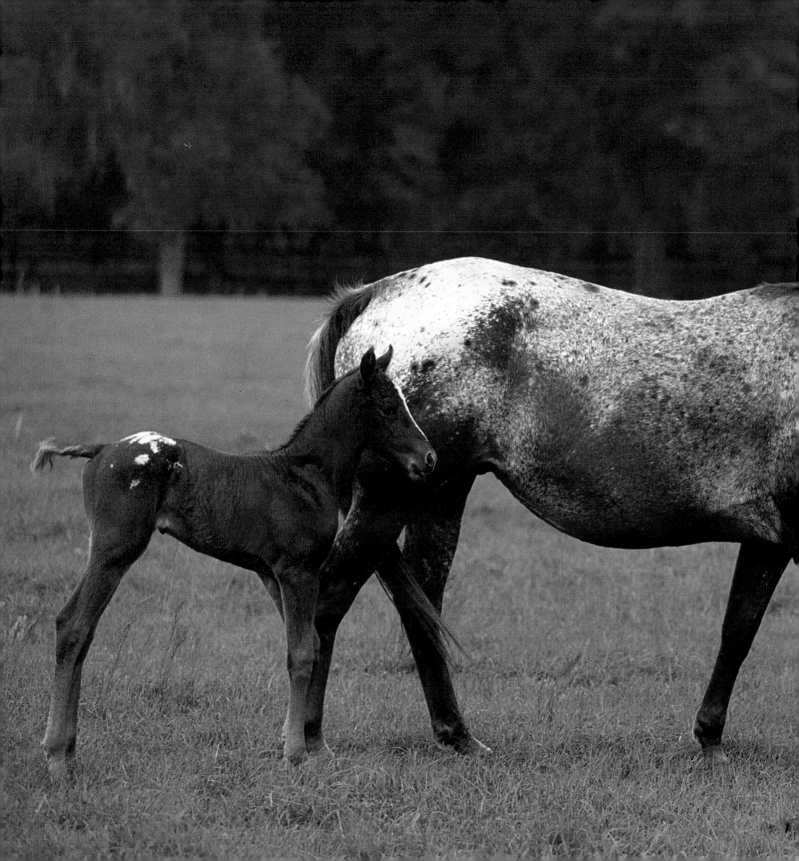

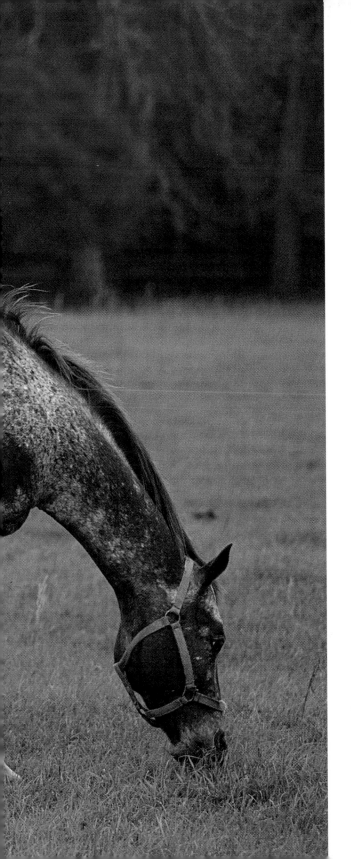

The breeders wait, their hearts pumping hard, their stomachs clenched. The time has come. The mare walks around her stall, occasionally stopping to paw the ground. Her spots become a dizzying blur. Spots, spots, and more spots. She has so many of them. But her foal, what will it be? A white leopard, like its father, bathed in a sea of bay dots? Or will it have a blanketed rump, speckled with tiny chestnut blood-drops? Or, they worry, will it have no color at all? Lost in thought, they are startled when the mare starts swishing her tail violently. She kicks at her belly with her back leg and then lays down on the straw with a groan. The moment has come.

Some time has passed, yet they don't know how much. All they know is a ghostly

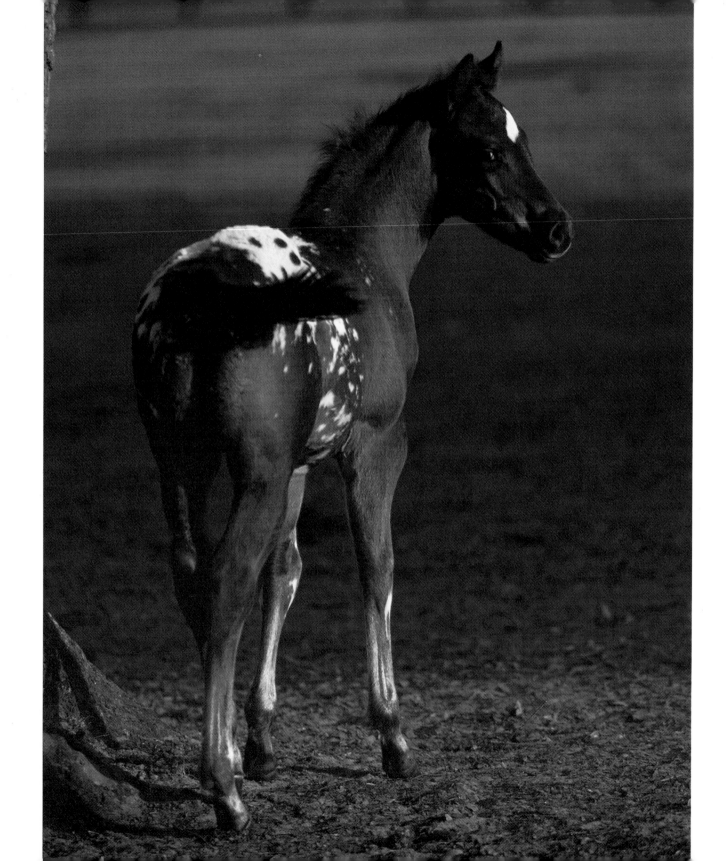

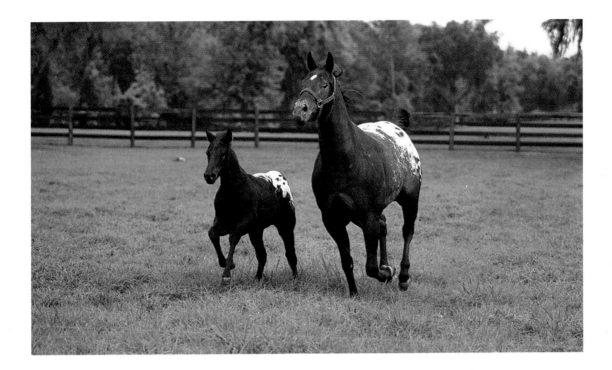

gray form is slipping out from under its
mother's tail, encased in its amniotic
membrane. For a few seconds, the newborn's
markings are hidden.

But then they see it, and the image
overwhelms them. It is something to behold:
a black colt, with a white blanket to his
withers covered with big, bold spots. As they
reach out to embrace him, his tired mother
rests her nose in the sweet straw. It is time to
leave mare and foal alone, to let them
discover each other and form a bond that will
mean life itself to the tiny baby.

The mare gets to her feet and licks the
colt clean as he trembles in the straw. Her
devotion is sudden and profound. Linked by
eons of evolution, mare and colt are two yet
they seem as one. Their new-found devotion

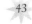

Spotted Babies

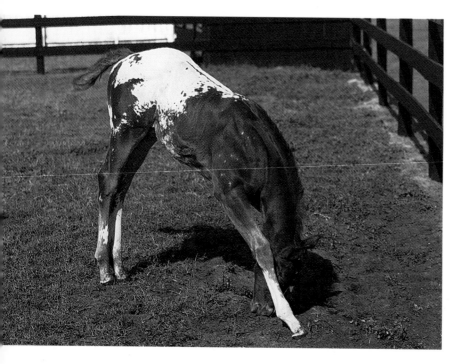

to each other joins them together in one of nature's deepest bonds. Their spots unite them in a swirling portrait of love and color.

It is not long before the colt begins to struggle to his feet. A powerful will to survive pushes him forward even though his long, bony limbs defy him. No matter how hard he tries to master them, they will not cooperate. As soon as he gets two up under him, the others refuse to follow. He falls to the straw several times, his head wobbling from the effort. His mother looks on, watching with interest. There was a time, long ago, when she struggled in just the same way.

The baby tries again, this time with a fervor lacking in previous efforts. It works! His legs stay under him, spread out away from his body at awkward angles. Though

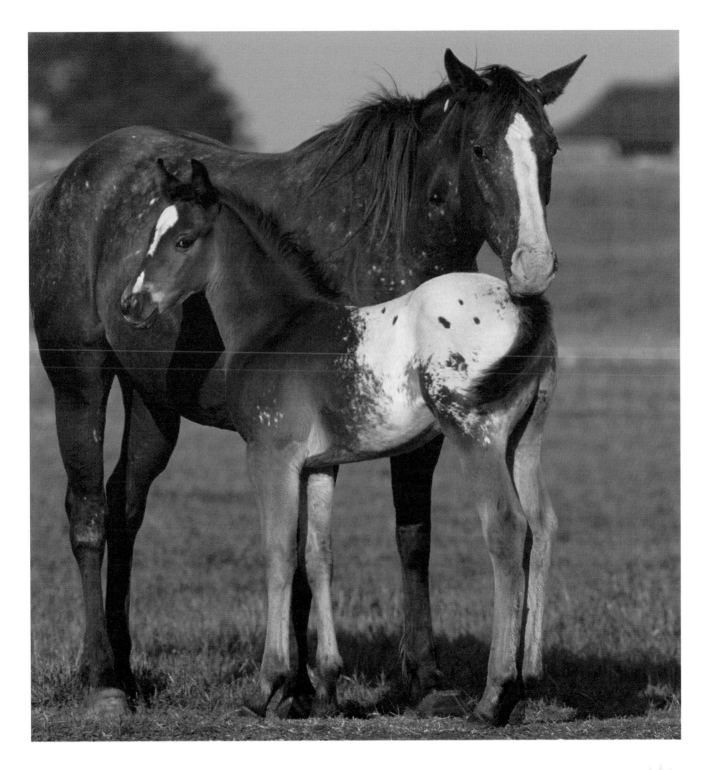

they are far from straight and solid, they manage to support him. Slowly, he moves forward until each one magically finds its place. He gingerly walks to his mother and begins to nurse.

Appaloosa foals are special creatures. Each is an individual—each has her own distinct personality and no two have the same exact markings. Some babies are feisty and stubborn, often colorful and spot-drenched, challenging their handlers to tame their wild spirits. Others are quiet and docile, sometimes with subtle colorations to match, easily accepting the instructions they are given shortly after birth.

No matter what job an Appaloosa will have when she grows up, her training as a young foal is the same: learn to trust humans,

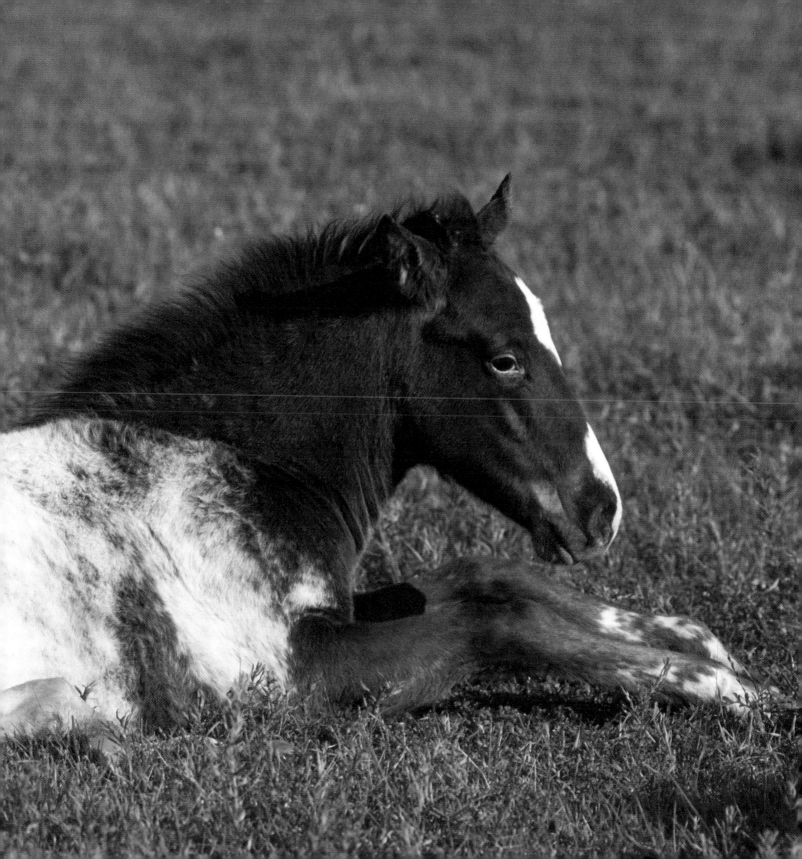

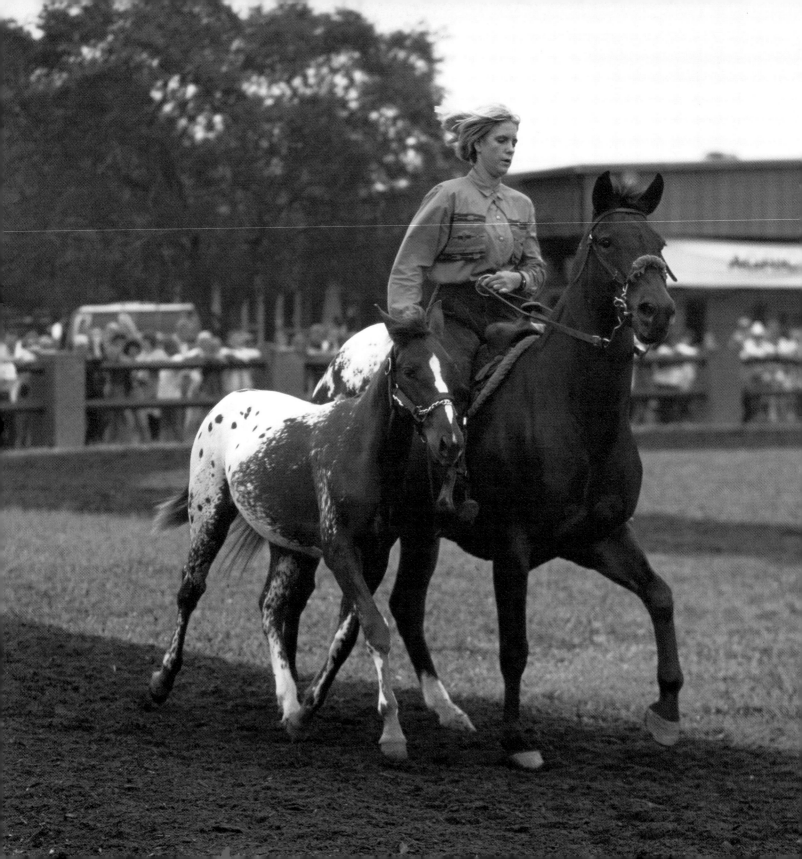

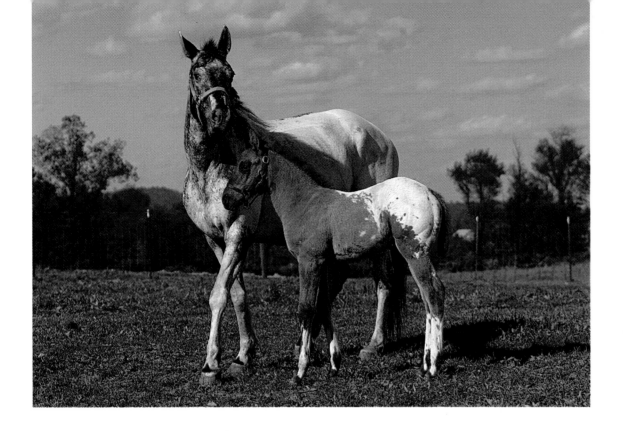

learn to be handled, learn to wear and walk with a halter.

All this is made easiest if the spotted foal is imprinted at birth, her human caretakers impressing their presence upon her young mind as soon as she leaves the womb. While the baby is still new to the world, here on earth only a couple of hours, her breeder will touch her all over, hands rubbing over her little body, placing fingers in her fuzzy ears, fondling her tiny striped hooves. All this makes an impression that will last this foal her lifetime. This handling says to the baby's impressionable mind, This human is part of my herd.

A tiny leather halter is also part of the imprinting process. Slipped over the baby's delicate head it becomes a part of the foal's existence from such an early age that there is never any question as to its presence.

Later in the foal's life, she will be taught to lead, following her handler first at her mother's side, then slowly away from her. Weaning will be traumatic for both mother and baby and may happen when the foal is anywhere from three to six months of age. But it is inevitable if the young Appaloosa is to follow her age-old calling, one for which she was bred for centuries: To serve her human companion.

The World Show

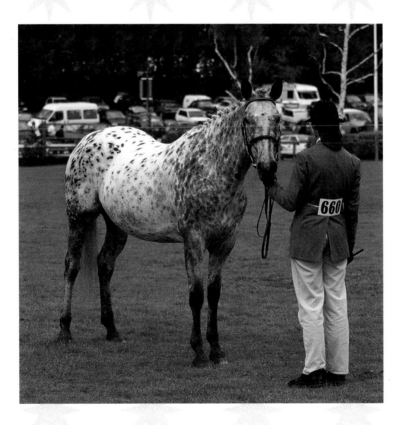

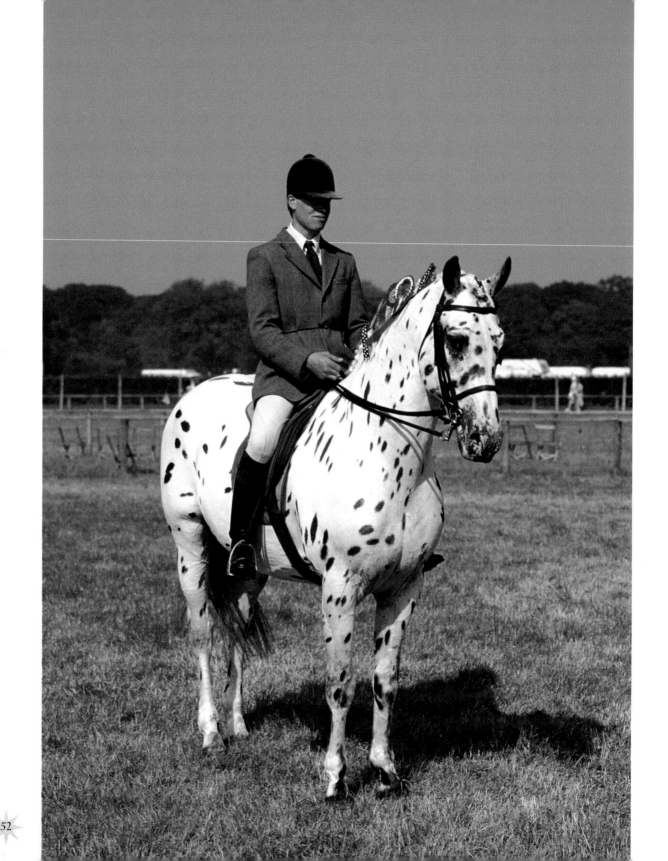

When the Appaloosa lived with the Nez Percé, he was required to perform many tasks. The breed took warriors into battle, hunted buffalo on the Plains, and pulled travois laden with the tribe's belongings. These same horses played in racing games, carried tiny children to and fro, and traveled with riders over many miles of rugged terrain. It is for this reason that the World Championship Appaloosa Show is considered a celebration of the breed's traditional versatility. Designed to show off the many talents of this incredible horse, the World Show puts the Appaloosa's skills to the test.

Each fall in Fort Worth, Texas, thousands of Appaloosas converge to demonstrate their accomplished skills. Classes with as much variety as is present in the breed are a part of the show's spectacle. It is the event for which many Appaloosas train their entire lives. It is the ultimate pinnacle in a show Appaloosa's success.

An important aspect of the World Show is the study of the breed's conformation. Judges scrutinize the balance and conditioning of each Appaloosa stallion, mare, gelding, colt, and filly in a series of halter classes, studying the horse's movement at the walk and the trot. Whether judged in traditional halter classes or in suitability for dressage—classes designed to evaluate a horse's potential for this most demanding discipline—the horses who bear the correct bone structure and the near-perfect fitness of an equine athlete are the ones who take the ribbons.

While the halter classes are important, action is what the Appaloosa is really all about—a fact emphasized by the vast number of performance classes at the World Show. To challenge their skills, horses are put to the test in competitions that demand highly trained and obedient mounts. Pleasure classes in western, English, and saddle-seat; cattle events featuring cutting, roping, and team penning; hunter events over fences; and light driving—these are some of the disciplines in which the Appaloosa is asked to perform.

While many other breeds also compete in these same types of events at their breed shows, there is one category of competition that is reserved solely for the Appaloosa: The Games. In the tradition of the Nez

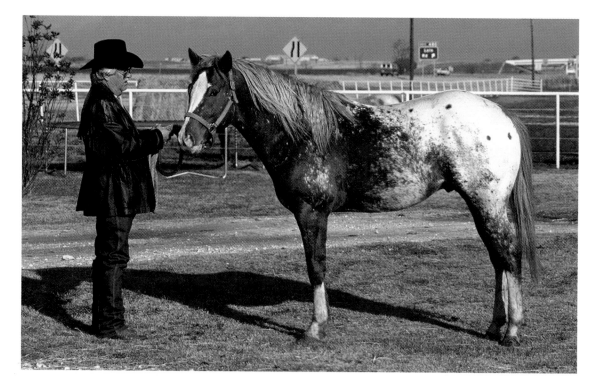

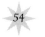

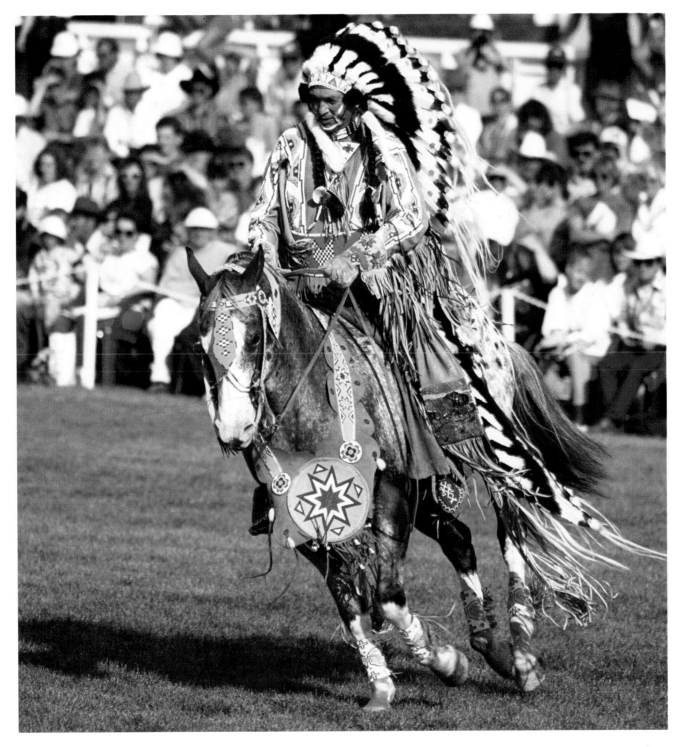

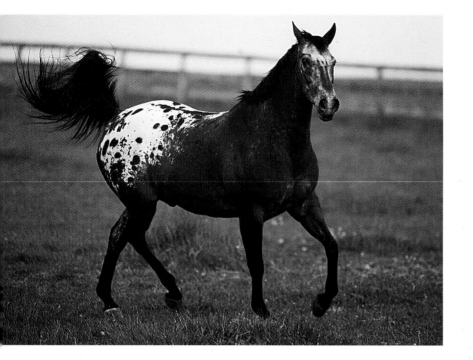

was a place in the Pacific Northwest where the camas root grew and fed the Nez Percé people. Warriors raced their horses there using stumps as obstacles to be encountered at top speed. At the World Show, these objects of nature are replaced by barrels, which horses must run to and negotiate one at a time, much in the way of a barrel race. The horse-and-rider team with the fastest time wins.

The rope race, keyhole race, and figure-eight stake race also demand swiftness, obedience, and skill. They are among the most exciting events at the World Show, and there is little wonder as to why: they demonstrate the intensity of the breed's stirring heritage.

As the games classes call for the Appaloosa to perform in the traditional way, the costume classes ask the breed to demonstrate its Native heritage. These classes, divided by rider gender, feature the exquisite trappings of the Plains Indians both on the horse and the rider.

In the men's and boy's classes, the warriors and braves of the Plains are portrayed. Riders are glorious in their headdresses, breechcloths, and leggings—elaborate representations of the most noble of tribesmen. The Appaloosa horses beneath them are adorned with many-colored breastplates, fringed saddlebags, and other authentic tack. Often painted with pigments made from earth, horses bear the earned symbols of their fantasy warriors.

Percé, the Appaloosa is asked to compete in races similar to those perfected by his ancestors.

The Nez Percé stake race is among the most popular of these games. Two horses are pitted against one another, their speed and dexterity at the ready. The horses start out at the same time, bolting forward, each running down the right side of a row of poles. As each horse reaches the last pole, he turns on a dime and weaves back through the same poles, then repeats the pattern on the left side toward the finish line. Perfection and speed are mandatory. A fallen pole means elimination as does failure to be first at the finish.

Another traditional Appaloosa game is the Camas Prairie stump race. The Camas Prairie

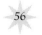

Chapter Five

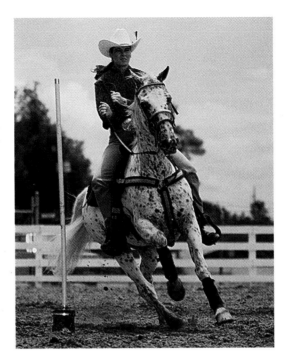

The women's and girls' costume classes at the World Show is a celebration of the importance of Native women on the Plains. The women and girls who rode the Appaloosa in that bygone time did so primarily to travel from place to place, although special occasions called for special dress for both rider and horse. The female riders in this competition wear the traditional feminine trappings of the time. Buckskin dresses adorned with seed beads, elk teeth, and abalone shells are among the costumes worn, and braid wraps, leggings, and moccasins bring the outfit together. The horse, in addition to his saddle, wears a decorated bridle, breastplate, and hand-woven saddle blanket, and may bear a cradleboard meant to carry an infant, or a medicine bag designed to hold special herbs.

To watch an Appaloosa costume class is to witness the beauty and splendor of a once-free people. The culture of the Nez Percé and other Plains tribes lives on in this spectacular ritual, judged according to authenticity and overall splendor. And there is no better mount to take this exquisite step back in time than the colorful Appaloosa.

CHAPTER SIX

Conclusion

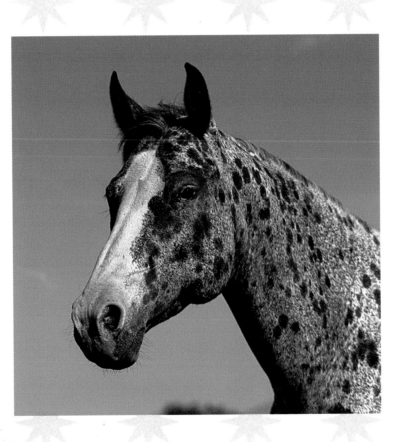

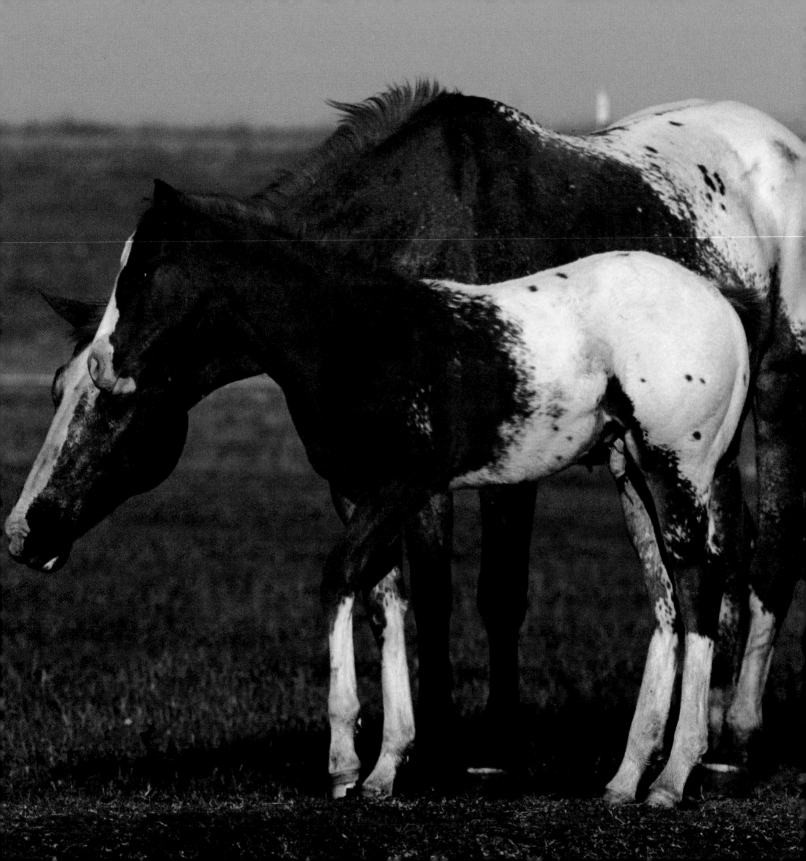

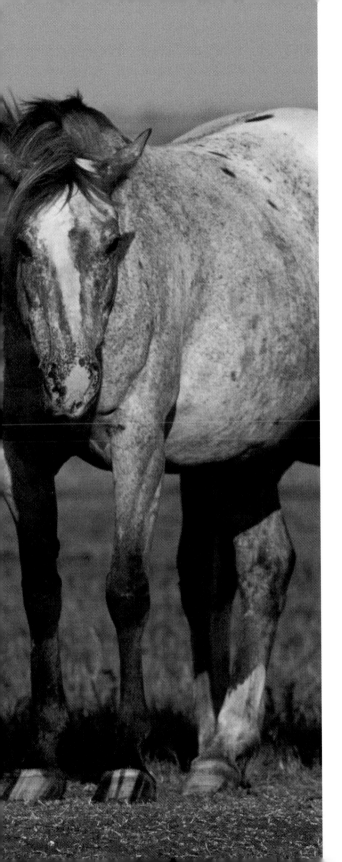

While there are hundreds of breeds the world over, there is only one horse whose destiny placed her in the hands of a Native American people. Her coloration is unique but so is her soul; she has been touched by a bond with a spiritual people, a bond that no other breed has ever known. She is the Appaloosa.

The heart of the Appaloosa is that of a Native warhorse. Her devotion to the one who loves her is undying. In battle, the horse's very life depended on the wisdom of her rider, and whether or not this warrior lived or died had much to do with his horse. Joined together as one in this life-and-death struggle, a profound connection that knew no earthly boundary was formed between the two.

The old ways, that ancient life in the wilderness, are gone forever. The simplicity, the oneness with nature that was the Nez Percé culture in its purest form can be no more. The memory of warriors on spotted mounts, of herds of thousands of Appaloosas grazing on the rich Palouse grasslands fades more with each passing day. No one who was

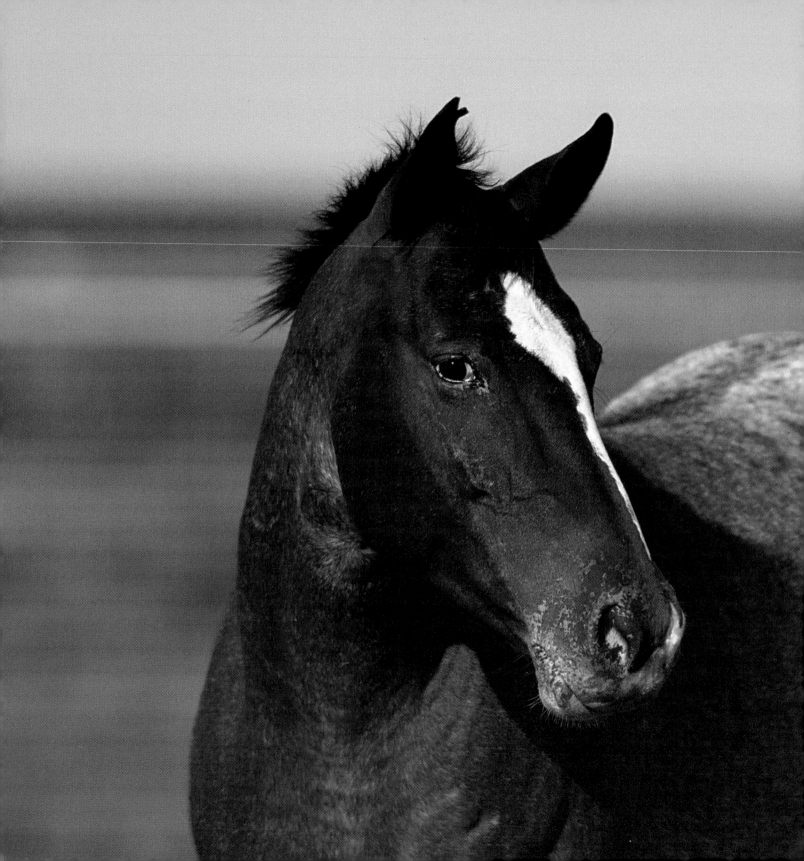

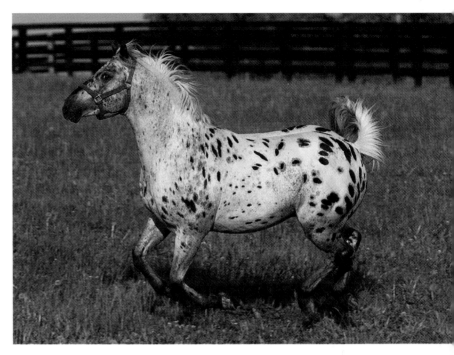

there is alive now. The great-, great-, great-grandchildren of these once-mortal spirits struggle to survive in our modern age. The past is dimming and some day shall be all but gone from our memories.

But there is one remnant of this time in our country's history, one remaining piece of the past. It is not a museum object sitting under glass somewhere, or an artifact yet to be uncovered in the Bitterroot Mountains. It is a living, breathing creature whose genes share the substance of those horses of long ago, and whose hearts bear the spirit of Chief Joseph's mighty herds. The Appaloosa horse, with all of her characteristics so important to those whose lives depended on her, is a treasure—one that needs to be guarded and cherished for as long as we all are here.

Conclusion

Glossary

bay: a horse whose body color is any number of shades of brown, with a black mane and tail

blanket: a type of Appaloosa marking that features a solid white area over the hip and/or rump. The blanket can be solid white or have spots of any color

colt: an uncastrated male horse between the ages of one and four years

conformation: the form or shape of a horse's body

dressage: a form of exhibition riding in which the horse receives nearly invisible cues from the rider and performs a series of difficult steps and gaits with lightness of step and perfect balance. Dressage also is a classical training method that teaches the horse to be responsive, attentive, willing, and relaxed for the purpose of becoming a better equine athlete.

filly: a female horse under the age of four years, unless she is bred earlier

foal: a horse of either sex aged one year or under

gelding: a castrated male horse

hand: a standard of equine height measurement derived from the width of a human hand. Each hand equals 4 inches, with fractions expressed in inches. A horse who is 16.2 hands is 16 hands, 2 inches, or 66 inches tall at the withers.

leopard: a type of Appaloosa coloration that features spots of any color on a white background, usually covering the entire body

pasterns: the part of a horse's foot just above the hoof and below the fetlock joint (ankle)

roan: a coloration featuring dark hairs as a base color, thickly interspersed with white hairs throughout the coat

withers: the highest part of a horse's back, where the neck and the back join